CRE
ATI
VITY

CRE ATI VITY

WHY IT MATTERS

DARREN HENLEY

First published 2018 by
Elliott and Thompson Limited
27 John Street, London WC1N 2BX
www.eandtbooks.com

ISBN: 978-1-78396-378-2

All author royalties earned from the sale of this book will be
donated to the First Generation scholarship fund at Manchester
Metropolitan University. The scheme supports young people from
backgrounds who do not usually enter higher education, enabling
them to access university, and to succeed once they are there. For
more information: http://www2.mmu.ac.uk/giving/firstgeneration/

9 8 7 6 5 4 3 2 1

A catalogue record for this book is
available from the British Library.

Cover design by kid-ethic.com

Typesetting: Marie Doherty
Printed in the UK by TJ International Ltd.

You can't use up creativity. The more you use, the more you have.

– MAYA ANGELOU

CONTENTS

A WORD ABOUT THIS BOOK

Imagine a world without creativity.

Nothing new would happen; there would be no original ideas; no new inventions or advances in science and medicine; no new products or services; no new books, shows, music or art; no solutions to new problems.

We would be frozen in a hellish form of suspended animation where our only reference points were what had happened in the past and what was happening right now in the present. There would be no hope of any difference or change in the future.

It is shocking, then, that we so often take creativity for granted, consistently undervaluing the positive impact that it can have on our lives – both as individuals and as a society. This book is my attempt to explain why creativity matters to our economy, our communities and our everyday lives, and why it should be given much more emphasis in our education system.

It is not an official Arts Council England publication; these are my personal opinions, but it is inevitable that my views are constantly shaped by my experiences at the Arts Council. I see the power of creativity every day; it's the catalytic ingredient that helps us to effect positive change in the world around us. We should do more to understand it, to talk about it, and to cherish the conditions that enable it to flourish. This is my case for creativity.

INTRODUCTION

Before dawn on a July morning in 2016, 3,200 people of all shapes and sizes assembled in the ancient port of Hull, stripped naked, painted themselves blue and paraded through the deserted city, sometimes lying down in the street like beached whales, sometimes posing in lines like frozen waves, and sometimes filling the city's squares like an incoming flood. A man stood on a stepladder shouting at them and taking photographs. They were clearly having a good – if chilly – time; but there was a prevailing air of serious intent, and the whole thing had some kind of underlying plan.

What on earth were they doing? And what is the relationship between this weird, woad-coloured event and our hopes for a better and brighter future?

It was of course a work of art. One of those extravagances that serve no obvious purpose yet can be mesmerising to watch, leave a lasting mark on participants and set in train a series of far-reaching consequences.

This work of art was *Sea of Hull*, created by Spencer Tunick for the Ferens Art Gallery in the lead-up to Hull's year as UK City of Culture in 2017. Using people like water, he marked the old hidden waterways of the port, recalling its past. The work had the liberating feeling of a tide released, and an urgent sense of a world that might yet come to pass should the sea ever reclaim Hull. But above all it was human; it had poignancy, defiance and hope.

Those who took part came from all walks of life and most had not had much to do with art of any kind before, never mind taken part in anything quite so extraordinary. Many have since talked about the sense of significance the project gave them. How powerful it felt to overcome their reservations, to share their vulnerability and their humanity and to be collectively part of something. To do something different; something absurd, beautiful, passionate and historic.

In a city that had spent decades not always getting the luckiest breaks, and where people were fed up of being told what to do and what to consume, those cold blue humans had begun to feel the revivifying power of creativity.

As I write, it's still early days in Hull's resurgence, but I can say with some certainty that *Sea of Hull* was the curtain-raiser

to a hugely beneficial twelve months. To my mind, Hull's year as UK City of Culture was an unmitigated, rip-roaring, awe-inspiring, life-enhancing success. It's a city that I know and love, having lived there for three years as a student in the early 1990s.

Hull has changed for the better and it's a real living, breathing case study of why creativity matters. Its year in the spotlight has managed to change perceptions about the city – locally, nationally and internationally. It has boosted the economy, attracting visitors, investment and jobs. It has broken down barriers between the city's communities. And it has had a direct impact on individual citizens – with more than 95 per cent of Hull residents seeing or participating in one of the many events that took place during the year.[1]

Like *Sea of Hull*, creativity flowed into people's lives and changed them.

WHAT DO WE MEAN BY CREATIVITY?

Creativity isn't an easy concept to define. Some might describe it as the realisation of something entirely unique; some would say that it is an aspect of character, and that you either have it or you don't; and others would give it a supporting role in other activities such as making a presentation in a business meeting, playing the piano well or being able to make a scale model of the Houses of Parliament out of matches.

We may well disagree about what creativity means as a process, but there is more consensus on what its results look like. For example, we think of ourselves as being a creative nation, because across the arts, technology, medicine, science, engineering and manufacturing sectors, we have produced innovative ideas that have challenged existing paradigms and moved us forward.

The force of creativity, coupled with industrial might, has long underpinned the wealth, influence and sense of worth not only of our nation, but also of communities and individuals. I've seen this for myself during a non-stop journey travelling the length and breadth of England over the past few years, witnessing the power of creativity in all its forms. In my first eighteen months as chief executive of Arts Council England, I encountered cultural activities and organisations in 157 different villages, towns and cities across England – and although I've now stopped counting the different places, I haven't stopped travelling, observing and learning since.

I don't for one minute think that creativity is the sole property of the artistic and cultural world. When I think of creative people, I think of individuals with creativity at the heart of the work that they

> **"** *It's not just artists who believe that creativity matters in their work.* **"**

do – and that applies to scientists, engineers and business people just as much as it does to artists. They use their imaginations; they innovate. They believe that creativity matters in their work. The anthropologist Agustín Fuentes argues that there's just as much creativity going on in the science laboratory full of test tubes and Bunsen burners as there is on the stage of a concert hall packed with violins and trumpets:

> Science emerges from an especially creative problem-solving system that can lead to the augmentation of existing solutions.[2]

Professor Roger Kneebone is the co-director of the Centre for Performance Science based jointly at the Royal College of Music and Imperial College London. The centre's research is aimed at tackling major challenges of performance across the arts, education, medicine, engineering, natural sciences, business and sport. A trauma surgeon by training, Roger's research brings artists and scientists together to come up with new ideas and new ways of working. The expertise of the scientists and medics informs the creativity of the artists; and the expertise of the artists helps the scientists and medics to think and act more creatively.

Roger is a passionate advocate for artists and scientists working together in pursuit of new understanding, as well as being a strong believer in the value of creativity in the education of both scientists and

artists. He maintains that there is a fundamental misunderstanding that people who do science don't need art, and that creativity is wrongly drummed out of students at medical school and through their scientific careers. He argues instead that creative thinking should be embedded in scientific education, rather than seen as something separate. It is a thoughtful, innovative approach that he applies to his own work. As a former war zone surgeon, he believes that the calm of a stark white surgical suite does not represent the best learning environment for other surgeons training to do

" *Creative thinking should be embedded in scientific education, rather than seen as something separate.* **"**

the same. Instead he uses immersive theatre techniques to recreate the kind of dramatic, high-stress conditions his students are likely to encounter in an area of conflict.

Like Roger, the most creative people – the people who really make change happen in society – are those who are interested in new ideas and new ways of working, no matter what their academic training. In short, they are keen to invent a new tomorrow, rather than simply repeating yesterday on an eternal loop.

CREATIVITY CAN BE NURTURED

Although I don't believe that creativity is the sole preserve of the arts, it's true that my thoughts on the subject have been largely informed by the world in which I work. I joined Arts Council England in

2015, and all that I have seen in this role has fired my curiosity about the value and potential of the cultural world that we support; what it teaches us about creativity and how that can help shape the lives of future generations.

In the public mind, the arts may epitomise creativity, but I think this can create a misleading impression of what creativity is and what we can do to encourage it. People tend to think that artists spend their days effecting a kind of magic, reaching into the void and pulling out a work of genius – whether it be on canvas or in clay, in a novel or a play, a musical score or a piece of choreography.

The truth is that the work of an artist is rarely so dramatic or revelatory. Most creative practice in the arts is built on the mastery of structures and processes; on understanding form, narrative and

technique. As musicians will tell you, it's not the notes that make music – it's the intervals between them. For an author or playwright, it's not just the words, it's the order they come in.

In the arts, what can seem like powerful moments of artistic revelation, of inspiration, that move us or shift our understanding about the world, actually come when someone rearranges the familiar patterns and changes the story. Work that we think of as being shocking is shocking only in context, because of the position it takes in relation to what already exists. We live in a world built of cadences, and we have an ear for variations and false notes.

This has echoes of the observation by the founder of Apple, Steve Jobs, that creativity is just a matter of rearranging things in ways that hadn't occurred to people before. But beneath this throwaway

definition lies the important fact that the ability to rearrange things in a new way requires a depth of knowledge. Creativity is not magic; we can learn how to make more of it in ourselves and how we can nurture it in others. And that, I think, is one of the key reasons why investing in it makes so much sense.

IMAGINATION SHAPES REALITY

Imagination is vital to creativity: if we can draw on our experiences to call up an image of the world in our consciousness, we can create an environment ripe for experimentation. For me, the words of the poet Lemn Sissay capture this beautifully:

> We turn to art and creativity because it
> is the greatest and truest expression of

humanity available to all. And all things are possible in the eye of the creative mind. To be more is first to imagine more.[3]

Thinking imaginatively is like living in a virtual dimension, but its results can be much more concrete. Many of the technologies that we now enjoy as realities, for example, were born in the minds of fiction writers. The human imagination is capable of exerting such a formative influence on reality that our world runs in a lagging parallel to fiction – as if we are riding on the coat-tails of dreamers.

The world of fiction can also generate the right kind of environment for future works of creativity: there is evidence that when children's literature emphasises technological achievement, the next generation will innovate more. Since the 1950s, studies

have suggested that at times in American history there has been a significant correlation between the amount of invention and original thinking in children's stories and the number of patents filed twenty to forty years later. Children are inspired by what they read and when they grow up, they too want to be original achievers.

After the Second World War, for example, came a generation of science fiction writers who foresaw many of our technological dilemmas – Isaac Asimov, Philip K. Dick and Arthur C. Clarke. Clarke's optimism about scientific progress was particularly influential. He was a

> **❝** *Children are inspired by what they read and when they grow up, they too want to be original achievers.* **❞**

scientist and an author. He had a fellowship at King's College London, a first class degree in physics and maths, worked in radar in the Second World War and published a visionary paper describing how we could achieve global communication via orbiting satellites – effectively conjuring up the concept of modern mobile telecommunications.

He was a man who believed that the human imagination had a vital role to play in anticipating and solving our problems. *2001: A Space Odyssey*, the 1968 film Clarke conceived and wrote with Stanley Kubrick, inspired governments to invest in space exploration, and schoolkids to be astronauts. It brought home to the public the enormity of the human adventure – and how it could be realised.

Imagination, of course, is not the same as creativity but it's fundamental to it. It is the ability to envision something beyond

what is around us right now, or what we have seen or experienced in the past. It can give us a glimpse into the future. Certainly, it may well be built on the known – an understanding of what's come before, and of our place in the present – but it's also about the unknown, about what could happen, about what might be. Ed Catmull, the president of Pixar Animation and Disney Animation, the man behind the studio that brought us films such as *Toy Story* and *Finding Nemo*, eloquently defines the relationship between past, present and future:

> We humans like to know where we are headed, but creativity demands that we travel paths that lead to who-knows-where . . . There is a sweet spot between the known and the unknown where originality happens; the key is to be able to linger there without panicking.[4]

Undoubtedly, there is much that we can learn from what has gone before, but we should value the creation of new understanding as much as old. As Albert Einstein pointed out, concentrating too much on knowledge alone restricts the possibilities of what an individual might achieve:

> The gift of imagination has meant more to me than any talent for absorbing absolute knowledge.

In his book *Originals: How Nonconformists Change the World*, Adam Grant notes the correlation between outstanding creative thinkers across science and medicine – such as Albert Einstein – and their relationship with creative practice in the arts. Researchers at Michigan State University examined the lives of every Nobel Prize-winning scientist from 1901

to 2005, comparing their connection with artistic and cultural activities to other leading scientists of their time. Those who picked up a Nobel Prize for their efforts were much more likely to have had an active interest in arts practice:[5]

ARTISTIC HOBBY	ODDS FOR NOBEL WINNERS RELATIVE TO TYPICAL SCIENTISTS
Music: playing an instrument, composing, conducting	2× greater
Arts: drawing, painting, printmaking, sculpting	7× greater
Crafts: woodworking, mechanics, electronics, glass-blowing	7.5× greater
Writing: poetry, plays, novels, short stories, essays, popular books	12× greater
Performing: amateur actor, dancer, magician	22× greater

We seem to make false divisions between disciplines, calling art and science unrelated when they are both dependent on the recognition of patterns and changes, and on a sensitivity to the secret music of nature.

Do we therefore need a more integrated and balanced approach to what we teach, finding the creative processes in both science and art, knowing that one form of creativity encourages another? Perhaps Tony Little, the former headmaster of Eton College, is right to argue that imagination is the most important quality that young people take into their later lives:

> It is imagination that gives us the flexibility and lightness of mind to respond to all that life has to offer, a resilience more profound than anything achieved through intellectual or physical discipline.[6]

It's a subject that I will return to in the final chapter of this book.

CREATIVITY BRINGS PROGRESS

For me, true creativity brings a crucial element of progress. When people are being creative, they are moving things along.

When we are being creative, we think about things in a different way; we have different perspectives. The answer to problems may seem suddenly obvious. We come up with ideas for things we never knew we needed, but we might need in the future. If we can see, imagine, or describe art or objects that for now can only exist within the realm of possibility, we are in fact drawing a line between the present and future – and in doing so we are creating a new direction in which our society may evolve.

I think this aspect of creativity matters now more than ever. Our world is built on a model of growth that requires a constant supply of creative ideas – a model that is being accelerated and changed by technology. In fact, the world is changing so fast that it is hard to keep track of where we are going or to imagine the consequences – good and bad – that could result from our present-day decisions and capabilities. The technology we are producing can improve and even save lives but it can also have negative repercussions such as reinforcing economic inequality. I believe we need creative thinkers who have the vision to take advantage of this technological surge and direct its economic dividends.

I also believe that creative thinking is vital when it comes to formulating the way we respond to crises – not only in our individual lives but in society at large.

Arguably there is just such a societal crisis on the horizon – centred on the place of the human in the world we are making. How far should we hand our decision-making processes over to technology? How will we live meaningful lives if the necessity for traditional employment is removed? How will we ensure that our lives continue to be purposeful through into old age at a time when we are likely to live far longer than our ancestors? How can we retain the advantage over technology that we currently enjoy? These are fundamental, even existential, questions that require creative answers.

Don't worry – this book is not intended to present a dystopian vision. I'm an optimist. The problems we face may actually offer the possibility of a golden age for cultural development. But grasping the opportunities of the future requires action

" *The next generation needs to be equipped with the creative skills to harness the power of technology.* **"**

today. To deal with the ever increasing pace and disruption of technological change, I believe the next generation needs to be equipped with the creative skills to harness the power of technology. You have to begin with education – but it takes twenty years to get the ideas out of the classroom and into the world. That's why I believe the case for creativity needs to be made now.

It matters to our society, it matters to me and I hope to show why it should matter to you too. Creativity belongs to all of us, to each and every one. Think of those naked people painted blue, huddling together in

the early morning light to create that work of art in Hull. In acts of creativity we can be ourselves and discover more about who we are; we can play, be happy and become more fulfilled; we can be relieved of the burden of scrutiny and of having to be right, of having to be beautiful, of having to conform to other people's expectations; we can challenge convention and offer a striking new vision to the world. Creativity has always been one of the defining qualities of humanity. In the future, I believe it provides our greatest hope.

1

CREATIVITY
AND THE
ECONOMY

This is a fast world. The philosopher and organisational thinker Charles Handy thinks we are living through a time when the life cycle of enterprises is getting shorter and shorter – a phenomenon illustrated on mathematical graphs by the familiar spoon-shaped line known as the sigmoid curve.

A graph, for example, showing the gradual rise and slow decline of ancient empires across hundreds of years would

feature a gently undulating sigmoid curve. But if we were to extend the graph up to the present day, the curves would get shorter and steeper. The Roman Empire lasted five hundred years; the British Empire around three hundred and fifty; the Soviet Empire just forty. The same is happening to commercial enterprises. They used to last an average of forty years before they collapsed or were taken over; now it's an average of just fourteen years.

It's an especially visible phenomenon in the world of the business giants. Take photographic company Kodak or mobile phone manufacturer Nokia. Both enjoyed massive growth based on the quality of their products, but both then took a dramatic nosedive. Each is an example of a company that realised too late that technology markets are driven not simply by product quality, but by function and by gratification.

With the advent of digital photography, Kodak failed to capitalise quickly enough on its position of pre-eminence in the photographic world. New digital technology rendered Kodak's traditional cameras – with film that needed to be developed in a photo lab – virtually obsolete.

Meanwhile, new entrants into the mobile phone market such as Apple and Samsung left Nokia trailing behind because they understood more clearly the opportunities for mobile phones to do so much more than make calls. To remain relevant, you need not only a quality product but also to think of all the different ways it might be used; listening to what your customers want is the key to building a sustainable business. Companies need to anticipate the effect of technological advances and to have the creativity to imagine what people might want in the future, not just what they need today.

Although technology is often described as 'disruptive', I don't think it's wise to think of it in a negative sense. Technology is bringing positive change at unanticipated rates, with investment swinging behind tech. Massive trusts and sovereign wealth funds are now disinvesting from fossil fuels and looking to renewables. Within our lifetimes, all private and public transport will turn electric. China is selling as many electric cars every month as Europe and the US combined. Tesla may make the headlines with its 'Insane' and 'Ludicrous' Model S drive modes (or indeed its space mission), but most major car companies have committed to an electric future. Volvo and Jaguar Land Rover will end production of pure fossil-fuelled cars within three years.

The technological revolution has brought enormous economic opportunities but at a pace that presents equally enormous

challenges to businesses. The sigmoid curve will develop ever more choppy wavelengths and according to Charles Handy, the trick to staying afloat is to anticipate your zenith and begin a second curve before the first curve peaks. Businesses need to innovate how they achieve innovations.

The record industry is a hotbed of artistic innovation, but major trends are often nurtured from humble beginnings. Today, artists with a background in the British grime scene are becoming increasingly dominant in the charts. After huge success on small independent labels, grime artists such as the 2018 BRIT Award winner Stormzy are now beginning to see their output championed by major record companies, with

> **❝** *Businesses need to innovate how they achieve innovations.* **❞**

multinational Warner Music entering into a joint venture with Stormzy's own #Merky label, following the massive impact of his debut album. Far from being manufactured by a huge corporation, Stormzy's music was originally the product of London's vibrant underground music ecology, through which a host of individual performers, producers, independent labels and venues were able to move quickly to establish a following and seize opportunities. Like the punk and dance genres that came in previous decades, the growth of grime in the UK in the past few years was born out of grass-roots creativity. The major labels will now invest to take it even further into the mainstream and also to provide a platform on the international stage.

Creative reinvention in pop music is by no means a new phenomenon. The late David Bowie, thanks to all of his many

incarnations, was often held up as an example of business acumen, and Madonna has pushed herself through numerous technical and stylistic reinventions to keep on top. Successful pop music artists evolve like great painters and sculptors. David Hockney has exhibited a consistent curiosity and open-mindedness when it comes to subject matter, medium and style, as shown by his effortless transition to creating art on iPads, while Louise Bourgeois enjoyed extraordinary longevity by eluding easy categorisation altogether.

CREATIVITY, HUMANS AND ROBOTS

Creativity, then, may offer a way for big businesses to survive and thrive amid this new industrial revolution. But what about individuals? How can we harness the power

of creativity to handle the undoubted changes that are coming our way in the world of work?

In 2013, a study by Oxford University academics reckoned that 47 per cent of today's jobs will be replaced by computers within twenty years.[1] Similar predictions have followed at regular intervals. In 2015, the Bank of England's chief economist said that 80 million US and 15 million UK jobs might be taken by robots.[2] In January 2017, McKinsey & Company, the private sector's leading business consultants, published a study that found about 30 per cent of tasks in 60 per cent of occupations *could* be automated by currently available technology.[3] Though the proportion of occupations that might be *fully* automated is less than 5 per cent, partial automation will impact almost all occupations to a greater or lesser degree. The impact could reach half of the

world economy. And this is what could be done with currently available technology; the pace of change might make the impact far greater still.

Automation will begin by sweeping up work roles that are routine, repetitive and predictable. That encompasses many tasks in areas such as manufacturing, quality control and food production. But robots are already taking over repetitive tasks in professions such as accountancy and the law, with paralegals having their jobs computerised, while most of us will have had a call from an automated telemarketer.

> **" Automation will begin by sweeping up work roles that are routine, repetitive and predictable. "**

Medical services are beginning to become automated as well. Even salvation can be digitalised, with apps now available for Catholics to track sin.

Mass automation could have revolutionary, violent consequences in a world in which 30–45 per cent of the world's working-age population is already unemployed, inactive, or underemployed, and where there has been a sharp decline in the share of national incomes paid to workers. The world is already full of stark inequalities. The most recent report by the UK government's Social Mobility Commission lays bare the growing problems of inequality, showing how there are seams of poverty in some of our most prosperous areas.[4]

Of course, total automation may not come to pass. Back in 1930, John Maynard Keynes (who advocated for the creation of the Arts Council) predicted that we would

be working fifteen-hour weeks by now. That hasn't happened. In fact, Charles Handy writes that in the last sixty years, automation has arguably only eliminated the occupation of elevator operator.[5] We are still evolving our attitude towards technology, striving for the ethical maturity that will allow us to decide how far individuals should be able to choose their relationships with technology. But we must also bear in mind the basic rules that govern corporate economics: if it is cheaper to develop and deploy robots to carry out a task currently performed by humans, it is more than likely to happen.

So which jobs are likely to remain in human hands? Perhaps it will be those that require the ability to handle such a wide variety of circumstances that it's not possible or economic to create a one-size-fits-all technological alternative. And perhaps, too,

> **"** *Creative roles are particularly resistant to automation.* **"**

it will be those jobs that require people skills as well as technical knowledge, such as psychologists, dentists, doctors and other caring professions. Research published by the innovation agency Nesta in 2018 suggests that creative roles are particularly resistant to automation, with 87 per cent of creative occupations at low risk of being replaced by a machine.[6]

It's not merely a question of which jobs will remain, but also of how we will carry on doing them. Indeed the redefinition of our working world has already begun. The most striking example is the rise of self-employment and the 'gig economy'. In the UK, the trend towards self-employment has accelerated since the turn of the century:

figures for October 2017 showed that there are now 4.86 million self-employed workers in the economy, a little over 15 per cent of all people in work.[7] The gig economy has encouraged people to dissolve the barrier between professional and personal assets, and put bits of their own lives onto the market place. For some people, it has proved to be a novel and flexible approach to earning an income; for others it is desperately hard work with little reward and no benefits.

Self-employment has gone hand in hand with a proliferation in small- and medium-sized businesses. There were a record 5.5 million private sector businesses at the start of 2016, two million more than in 2000. Nearly all of these are defined as small- or medium-sized. Collectively, they employ 15.7 million workers – 60 per cent of all private sector employment – and have

a turnover of £1.8 trillion – that's 47 per cent of all private sector turnover in the UK.

And out there, glowing like stars among those small business figures, are the creative industries and the arts and cultural sector, which I believe have exactly the right kind of energy and ideas to take advantage of this new world.

CREATIVITY REWARDS INVESTMENT

Plenty has been written in recent times about the success of our creative industries – this bustling aggregation of arts, tech, design and knowledge, where sectors and skills blend. It is a bright cluster of businesses and talents within the overall system of our economy. It puts a smile on our face as a nation. It gives us a sense of self-confidence. And it makes jobs and money.

The creative industries contributed £91.8 billion to the UK economy in 2016 – that's 5.3 per cent of the UK economy (bigger than the combined totals of the automotive, life sciences, aerospace and oil and gas industries). Between 2010 and 2015 they grew by 44.8 per cent – faster than any other sector.[8] They have also outperformed other sectors in terms of employment growth and they are a net exporter of services. In total, the UK creative industries employ almost two million people in the UK and exported £21.2 billion of services in 2015.

A recent independent review led by Sir Peter Bazalgette predicted that the creative industries could deliver close to £130 billion GVA (Gross Value Added) by 2025, and approximately one million new jobs could be created by 2030.[9] The review pointed out the extraordinary advantages

we have in this area – we have the language, we have the intellectual property, and we have the talent – and how business could make more use of the creative skills of the sector. As Baz observed:

> The skills and business models of this sector and of the wider creative economy are those which many experts judge to be of increasing importance: blended technical and creative skills; collaborative interdisciplinary working; entrepreneurialism and enterprise.

One of the key words here is enterprise, which I think implies a crucial measure of dynamism. As the organisational psychologist Adam Grant notes, successful creative people are distinguished not by a dramatic qualitative difference in what they do, but by the energy of their production.[10] They

have lots of ideas, of which a small number will be successful.

Mozart composed more than 600 pieces before his death at thirty-five; Beethoven produced 650; Bach more than 1,000. Picasso's work includes 1,800 paintings, 1,200 sculptures, 12,000 drawings, plus prints, rugs and tapestries. The same is true of great scientific inventors. Between the ages of thirty and thirty-five, when he pioneered the light bulb, the phonograph and the carbon telephone, Edison filed more than a hundred patents for inventions.

Creative thinkers produce a lot of duds – but also those few vital gems. Creative thinking moves things forward and, crucially, it's at home in the restless world of technological change.

Within the creative industries, the arts and cultural sector has been a particularly

stellar performer. The latest available figures show that in 2015 the contribution to the economy by the arts and the cultural industries grew year-on-year by 10.4 per cent to £11.8 billion, while the economy as a whole grew by 2.2 per cent. The government is now making back £5 in taxes for every £1 it puts into the cultural sector. If that alone isn't a case for investing in creativity, then I'm not sure what is.

Arguably, we are only enjoying this success because of a far-sighted policy of public investment in art and culture that has been shared by all political parties since the Arts Council was created more than seventy years ago. By democratising public art, sharing our national cultural treasures, encouraging participation, and investing in infrastructure and generations of talent, we have fostered the creative skills that have helped the cultural sector to emerge as a

significant economic force – perhaps just at the right time.

While this is an undoubted success story, I would argue that these same creative skills should be integrated far more widely into our economy. The Victorians understood this, which helped them lay the foundations for the manufacturing successes of the first Industrial Revolution. In Victorian times the state was a more active funder of culture than people suppose. The Great Exhibition of 1851, for example, was organised by Henry Cole who had previously reformed the national network of public design schools. These had a particular emphasis on industrial design that would be useful to manufacturing. The schools were supported through the Department of Science and Art. In 1870, this government department had a budget in excess of £206,000. Projected forward as

a proportion of GDP, this might be something like £300 million in today's money.

The huge profits from the Great Exhibition then funded the creation of the South Kensington Museum that eventually grew into the Victoria and Albert Museum, the Science Museum and the Royal College of Art. Here, there was a cross-fertilisation between the schools of medicine, art, science, natural history, food, animal products, patents and economic science, to name just a few. The V&A was a bustling, hands-on learning environment, in an age when the function of many universities was simply to award a degree.

Things changed. Art and science parted ways: teaching became more restricted to the classroom and lecture theatre; business holed itself up in the office; and culture became the province of the artist.

Now, as a new industrial revolution

" The technology business is becoming a common ground for art and industry. "

gathers pace, I think that these damaging artificial divisions are disappearing; the boundaries between disciplines are changing. The technology business is becoming a common ground for art and industry, and higher education is again taking a leading role in the life and work of our communities. I believe this is an emerging trend that we need to encourage. As I have travelled around England, I have seen for myself how often universities are enterprising and powerful forces for growth and innovation in their local towns and cities, doing an increasingly important job both as civic leaders and as artistic and cultural

custodians. The vital role that universities are playing here should be more widely recognised and valued.

At present, London is our cultural powerhouse, supplying 45 per cent of jobs in the art and culture sector. It has a historic advantage as the seat of government, and as a home for many cultural treasures that have a gravitational pull on talent. It is a vast 'creative cluster' of cultural organisations and creative industries that I believe can work alongside and influence other sectors of the economy – demonstrating and sharing the kind of innovative thinking that has helped them flourish in recent years.

If we want to use the energies of our growing cultural sector and our creative industries, then we should look to replicate this in other cities all over England. We are seeing it beginning to happen, in places like Birmingham, Brighton, Bristol, Gateshead,

Leeds, Leicester, Liverpool, Manchester, Newcastle, Nottingham, Salford and Reading, where creative businesses flourish next to galleries, theatres and new spaces for film, music and performance, sharing ideas and resources.

Investing in creativity has already paid off for our economy, but I believe the case for further investment is stronger than ever. In a world of disruptive technology, the advantage is likely to lie in the nimble hands of the creatively orientated entrepreneur, and all those who cultivate their

> **"** *Investing in creativity has already paid off for our economy, but I believe the case for further investment is stronger than ever.* **"**

uniquely human skill-sets. If we want to ensure a lasting role for humans, we need to figure out where we are on our own sigmoid curve so that we can imagine, anticipate and ride out the changes that are coming. That means acting now to invest in the kind of creative skills that support this forward-thinking, visionary approach. Otherwise, in the fast-moving economy of the tech world, we will be overwhelmed by the speed of the coming revolution.

2

CREATIVITY IN OUR COMMUNITIES

Manufacturing once dominated large areas of Britain, creating close-knit communities that attracted immigrants from all over the world. Shipbuilding in the north-east; mining and steel in Yorkshire; weaving in Manchester; cars in the Midlands. A town like Middlesbrough came into being for the sole purpose of heavy industry. That defined the culture of the place, its sense of self-worth and its values. But the world

changed. The British manufacturing industry as a whole experienced a dramatic economic decline – unable, even with government intervention, to compete globally.

Communities up and down the land were hit hard – and not just in the economic sense. Something we have to remember is that these towns and cities were once places where things were made. It gave them a different sense of value and that's an important and deeply emotional idea. It is hard to go from being people who make and create things and are respected for that, to being viewed solely as potential consumers.

If we expect these communities to pick themselves up – to regain belief and confidence and to reinvent themselves for a new purpose – then I believe we need to help everyone to recognise and unleash the power of their own creativity.

The transformative, reviving power of creativity is particularly palpable in towns and cities such as Bradford, Coventry, Folkestone, Hull, Luton, Middlesbrough, Plymouth, St Helens, Stoke-on-Trent and Sunderland, which have experienced the trials of post-industrialisation but have decided to rebuild the narrative of their place in a large part through investment in the arts and in culture.

No community is solely defined by its contribution to the economy; other bonds such as family, friendship, religion and sports teams are all powerful societal forces. And I'm not suggesting that artists and cultural institutions are some sort of silver bullet that can perform miracles on their own in these places. Investment in education and skills in new areas of the economy will also be critical for these communities, but alongside this, culture has a key role to play.

A CREATIVE RESPONSE TO OUR HISTORY

An important part of repairing a community's identity is to celebrate its past, and that's something artists, performers, creators, producers, libraries, museums and arts organisations can do well – particularly when they are deeply embedded within the everyday life of their community. When our collective narrative fails, we go back to the past, look at where we have come from, and build a new storyline. But our response needs to be creative: and by that I mean it needs to have the sense of forward movement that characterises creativity.

Many people make the mistake of responding to change by retreating into a bygone age, seeking out the reassurance of nostalgia. The pace of present-day change is too alienating, media headlines are too

alarming, and the future appears too wor-rying to contemplate. No, we cannot live in the past, but we can visit it for inspir-ation, and for lessons. And the great lesson of history is that the next day can be better than the day before. In fact, if we take a step back, it's possible to realise, despite all the headlines, that the world is becoming a more peaceful and more tolerant place.

However much we yearn for the past, it's not possible to bring it back. The mills and mines and factories and shipyards will not rise from the ground again. They are gone, but in many places there is an enduring creative spirit that emerges in other ways. It's interesting, for example, that a city such as Manchester, with its strong manufacturing history, should have produced so many extraordinary working-class bands. The same is true of Hull, of Coventry and of Sheffield.

Sunderland is a city that led the way in building ships and cars and in the art of glass-making. It is now home to the National Glass Centre, where you can see the myriad forms of glass products – blown glass, pressed glass, cut glass – that could once be found in homes across the world. I was particularly struck by a film of glass-blowers at work in the 1960s, set to a jazz sound track, which brings out the skills and artistry of this industrial practice; these men are like musicians riffing on the well-known tune, and in their hands the production of glass becomes a performance of grace, delicacy and fine judgement.

The National Glass Centre was established in 1998 to celebrate the heritage of glass-making in Sunderland, to inspire a sense of civic pride and to support the revival and growth of a new kind of glass-making industry in the region. It's a place

where the past is being curated in a new way under the thoughtful custodianship of the University of Sunderland, giving the public the chance to draw lessons and inspiration from what has gone before – a creative approach that I have seen in a growing number of museums and galleries across England.

Celebrating the creativity of industrial manufacturing allows us to rediscover its value. It moves the past forwards, if you like, and makes it aspirational. You only have to watch or, as I have been lucky enough to do, to take part in the displays of live glass-blowing in Sunderland, to see the fascination that this craftsmanship

> **" Celebrating the creativity of industrial manufacturing allows us to rediscover its value. "**

inspires in the audience. It's important to acknowledge the past without attempting to recreate it; our manufacturing processes, rediscovered as creative art, can become something new. It's no coincidence that amid the boom of small businesses that I mentioned in the last chapter there are so many crafts-based enterprises.

CREATIVITY AS A COMMUNAL VALUE

We should not forget that a huge number of our communities – both large and small – have been forced to change rapidly in the last twenty years or so. Even formerly isolated villages where populations were built around a few long-established families may now be made up of retirees, farmers, second-home owners, older single people and relocated financially poorer younger

couples. And how are these disparate new arrivals supposed to get to know each other and form a sense of community? Popping in and out of the rural post office or pub is an impossibility if they have closed. Instead, we now have scattered virtual communities, which often require a change in the identities and the sense of self of the individuals who inhabit them. Yet, the vast majority of people do also still want a sense of collective life rooted in the physical reality of where they live.

Identifying the shared culture of these disparate communities requires some degree of public conversation, whether that is in words or action, but how will they begin that conversation and develop it when the old public forums have gone? One answer would be to take advantage of a groundbreaking new programme called Creative People and Places. Launched by

the Arts Council in 2013, this is about bringing people in a community together by involving them in a long-term arts project in which they can all become invested. There are currently twenty-one projects nationally and more than 90 per cent of audiences come from neighbourhoods with low or medium levels of arts engagement. They work with arts professionals, but the process of creativity and the direction it takes is driven by the people themselves and their shared ideas about culture. It's their own communality that they are building.

The programme can take any direction; there's no top-down creative line, so it can throw up ideas to use the arts to improve well-being and health; to deal with addiction; to make places of work attractive; to create celebratory moments or to take over a community with yarn-bombing. There are films, festivals, concerts and tea parties.

Between 2013 and 2016, some 1.35 million people took part. It's a response to globalisation that encourages people not to put up barriers, but to seek out humanity, starting with their neighbours.

Bringing communities together can also help us tackle the growing issue of loneliness – one of the most poignant and insidious side effects of life in modern society. Loneliness and isolation have been shown to have major negative impacts across a range of conditions – including depression, dementia and obesity. Financially, it will cost us all more. According to a report commissioned by Social Finance, socially isolated people are more likely to see their doctor or to visit the accident and emergency department at their local hospital. They are three-and-a-half times more likely to end up in local authority funded residential care.[1] The Office for

Budget Responsibility projects total public spending excluding interest payments will increase from 33.6 per cent to 37.8 per cent of GDP between 2019/20 and 2064/65 – equivalent to £79 billion in today's terms – due mainly to an ageing population.[2]

It's true that loneliness is a particular problem for older people, who would previously have been supported by social structures and families that have now splintered. (Interconnectedness in a digital sense is invaluable, but a need for human contact often means just that – to be in the presence of another. To see, hear and touch them.) It's also true that our population is ageing. In 2016, the government report *Future of an Ageing Population* revealed that by 2040, nearly one in seven people is projected to be aged over seventy-five. Currently, one in twelve people in the UK is in this age group, so the figures are

predicted to rise dramatically, both in absolute numbers and as a percentage of the overall population.[3]

But what if we were to think more creatively about ageing? To see it not as a process of diminishment, a condition that needs treatment, but as another stage in life where we can acquire new skills, contribute to society in new ways and participate in a whole range of social and creative activities that will help to keep our minds and bodies alive, and allow us to share our experience with other generations? We should live longer lives, not slower deaths. We should keep inventing and discovering and being creative.

Greater participation in the arts, whether writing and drawing or making music, or more physical activities such as dance, are showing their worth as social activities that bring older people together,

> **❝** *We should live longer lives, not slower deaths. We should keep inventing and discovering and being creative.* **❞**

and as ways to tackle specific conditions. 'Memory boxes', for example, have been shown to be useful for those with dementia; dance is being widely used to help older people stay mobile and avoid falls, which cost the NHS £2.3 billion a year. There are projects like 'Meet Me at the Albany', a popular all-day arts club for the over sixties, based at south-east London's Albany arts centre, where older people can work creatively alongside artists.

The Albany is a good example of a creative hub capable of building links in its local community, and I think we should

be doing more across the country to build similar hubs and co-operative movements. This is something we can do by establishing virtual as well as physical centres. Technology, for all of its disruptive power, can also be harnessed to empower us as individuals and to bring like-minded people together. Lobbying through social media, for example, is proving to be increasingly effective, with consumers putting pressure on companies to change their behaviours. The Internet is a forest of forums and notice boards and informal alliances.

I believe we could multiply these community-building efforts by tapping into the power of existing creative and cultural institutions that have access to knowledge, resources and ways of thinking. Big towns and cities have universities or major cultural organisations. Smaller towns might have a library.

Libraries consistently emerge from surveys as being especially trusted institutions, safe spaces and resources of integrity. They are also making an evolutionary journey towards being communal, creative hubs, where you will be as likely to access a 3D printer as a novel. Maybe we should develop these trusted community resources so that they become miniature local universities – centres for life-long learning and bases for new kinds of co-operative, creative work. Centres of citizenship.

I certainly believe that we should all be more committed to, and more creative about, life-long learning. What if it meant that all of us would have an ongoing learning aspect to our lives, through a continuous relationship with a college or university, which would provide us with access to skills, pathways for progression and networks for employment? And what

if these larger institutions had a reach and a physical entity in our communities through local libraries? Yes, we can do so much online; but technology is always complementary to the human experience; sometimes better, sometimes worse, but always in relationship to it.

Turning our libraries into community hubs, creative spaces and centres of life-long learning would, to my mind, have many benefits. It would bring local people together; it would help tackle the scourge of loneliness; and it could even counter some of the effects of post-industrialisation

" Turning our libraries into community hubs, creative spaces and centres of life-long learning would, to my mind, have many benefits. "

by reviving a sense of pride and common purpose in the local community. It would also have a direct and positive impact on the lives of individual citizens, not least by bringing them into closer contact with the power of creativity – and it's the effect of creativity on all of our lives as individuals that I want to examine next.

3

CREATIVITY
IN OUR
LIVES

What we know about happiness tells us that we are doing all we can to make ourselves unhappy. In Britain, it's the custom to blame the weather for our moods, though the problem may lie with our own choices.

Dr George MacKerron, an economist at the University of Sussex, created the 'Mappiness' app, which pinged 20,000 users throughout the day, asking them to record their happiness levels and what they were

doing at the time. The app generated more than one million responses, from which Dr MacKerron was able to compile this list of activities that make people happier:

1. Intimacy, making love
2. Theatre, dance, concert
3. Exhibition, museum, library
4. Sports, running, exercise
5. Gardening, allotment
6. Singing, performing
7. Talking, chatting, socialising
8. Birdwatching, nature watching
9. Walking, hiking
10. Hunting, fishing
11. Drinking alcohol
12. Hobbies, arts, crafts
13. Meditating, religious activities
14. Match, sporting event
15. Childcare, playing with children
16. Pet care, playing with pets

17. Listening to music
18. Other games, puzzles
19. Shopping, errands
20. Gambling, betting[1]

Within that top twenty, at least half a dozen are what most people would think of as being artistically creative activities. It's noticeable too that there is no mention of the Internet, iPhones or computer games. They do eventually appear further down the list, but it would seem they do not make us especially happy despite the inordinate amount of time we spend on them.

We all want to live emotionally and intellectually rich and fulfilling lives. And, as this list shows, many of the things that make us happiest involve creative activities, by ourselves or with others. Here, then, is another case for creativity – its power to improve individual lives.

If you look more closely at Dr MacKerron's list, I would suggest it's possible to find an element of creativity in many of the other hobbies included. What is gardening, for example, if not a form of sculpture using natural materials? And if fishing were just about catching fish you could fill your bath with carp and then scoop them all out again in quick order. No, fishing is much more than that; it's silence and the river, the art of the cast and the choice of the lure, the mesmeric visual interplay of trees and shadows and ripples. It is a way to encounter the world, and let your mind run free while you wait for the tug on the line. It is, in fact, an acting out of a metaphor for inspiration. Many artists, writers and scientists have loved fishing for that reason. Maybe you'll catch something, maybe you won't, but you'll enjoy the experience. It's a process of everyday

creativity through which you can encounter the world in fresh ways, gain new perspectives and restore your sense of well-being.

The concept of 'everyday creativity' has been around academically since the late 1980s, when the phrase was coined at the Harvard Business School, and defined as everyday expressions of originality and meaningfulness. It's something that we humans have been doing since we began cave painting, expressing ourselves in art and music and words that mirror back to us our consciousness, that explore, validate and develop our experiences and our identity.

Everyday creativity covers the myriad acts by which we build our lives. Observing, reflecting, solving problems and applying our imagination – the activities it covers do not have to produce art, but they tend to follow the same processes that artists use.

❝ *Everyday creativity covers the myriad acts by which we build our lives. Observing, reflecting, solving problems and applying our imagination.* **❞**

Up to the recent past, we often had to exercise our ingenuity and creative talents just to get by; we fixed our cars, rewired our speakers; knocked up a bookcase from scrap wood or repainted an old set of dining chairs. We made, sawed and sewed. Children knew how to take an engine to bits, how to make a bow and arrow or climb a tree, use a compass, read a map, bake scones; stuff worked in ways that could be held in our heads and put into practice by our hands.

That was an analogue world. Most of

us have no idea how today's digital world works. We are surrounded by extraordinary technology, but few of us know anything about the language of coding – the key to unlocking our creative access to these resources: exploring them, playing with them and shaping them. In fact, we often regard those that do customise their digital lives in this way as unacceptably unconventional – as hackers operating outside the law.

I would argue that this has become an important barrier to our everyday creativity, and that we need to indulge in more digital discovery and play if we are not simply to retreat from the tech-dominated daily world. Because to do that would not only be to deny ourselves the happiness and fulfilment of this kind of creative activity, it might also mean ceding creative control over our own future as a species.

A DEFENCE OF OUR HUMANITY

In his bestselling book *Homo Deus*, Yuval Noah Harari identifies the challenges facing us as we become increasingly enmeshed with the technology we have created. The most fundamental issue that he describes comes with the de-coupling of consciousness and intelligence, which goes to the heart of our significance as human beings.

Harari argues that the algorithms of technology will inevitably be more intelligent than us, and asks how much authority we are prepared to cede to them, before our human consciousness – our self-reflective state of mind – becomes irrelevant. He does not advocate any particular approach – he simply points out that this phenomenon is happening: advances in life sciences in parallel with technology are making it possible to analyse the human experience in such detail

that we can increasingly be thought of as little more than streams of data. And in our role as consumers, we are happily delivering more and more data about our lives into the hands of algorithms, giving rise to virtual versions of ourselves locked into the heart of the so-called 'Internet of Things'. This matters because algorithms are now mining this data to guide us towards making increasingly significant choices in our lives.

As consumers we are already becoming aware that the products advertised to us have been chosen specifically because some algorithm somewhere has judged that these are the items we might want or need. Even the news stories we read online might in some cases have been chosen to suit our anticipated tastes. It doesn't then require a huge leap of the imagination to see how such technology, refined so that it is even more sensitive to our behaviour, might

actually start to shape our choices rather than simply facilitate them.

What does all this have to do with creativity? I believe that we need to think now about what the future world will look like, and what our position in it will be. If we anticipate a world in which we make fewer and fewer decisions, we are in danger of losing control over our lives – and over all the autonomous technology that is gradually making its way into our homes, into our classrooms, on to our roads and even on to the battlefield.

We are likely to see autonomous vehicles on the road within the next few years, for example. Many thinkers and technicians have pointed out that there is no problem with a world in which all cars are driverless; the problem is the mixture of driverless and human driven, for only one of these is unpredictable. Once technology is introduced

into an area where humans also operate, it almost invariably shows up our imperfections. Only one side faces redundancy.

There will soon come a tipping point when we will have to decide how many of our decision-making processes we cede to our technological creations. There needs to be a process of education before we reach that point, during which we should equip our children for life in this digital world (something I will discuss in the final chapter). Just as importantly, though, we should use this time to explore what is most precious to us in our lives as humans, and to promote the qualities that set us apart from – and above – technology.

We question, we think, we talk, we make, we change – so long as we can do this, we are still in charge, and still responsible. Creativity in our own lives is the route to self-determination.

LIVING OUR LIVES AS ARTISTS

If the case for creativity is becoming more important than ever, the good news is that being creative is something we all have a talent for. We are all artists in our own lives. We make up stories and reinvent ourselves and redesign our environments. This is part of everyday creativity, and I believe that we can harness even more of the power of creativity if we combine our natural talents with artistic practice.

The arts have long been the route for self-determination, both in terms of giving people an individual voice, of being able to say 'this is the real me', and in assisting the social mobility that a healthy society needs. So, which creative skills useful to self-determination might someone take from participating in the arts?

The most fundamental, perhaps, is the

playfulness that's so essential to creative discovery. Participating in the arts is a way to reawaken the invention, imagination and immediacy that we all have inside us. The novelist Ben Okri writes wonderfully about this playfulness:

> Creativity, it would appear, should be approached in the spirit of play, of fore-play, of dalliance, doodling and messing around – and then, bit by bit, you get deeper into the matter . . . Do not disdain the idle, strange, ordinary, non-sensical, or shocking thoughts which the mind throws up. Hold them. Look at them. Play with them.[2]

Then there is the age-old ruse of being another, of pretending, of acting. Being creative with the truth; being imaginative liars; making ourselves bigger. Faking it.

If we can act, we can think ourselves into another perspective and we can see ourselves as others see us. We can explore the massive realm of empathy, and we can see the potential advantages that others might perceive in a situation.

When we lack the facts or resources to give us an advantage, we can still explore the world through instinct, intuition and affinity. It's what teenage children do when they speculate what mum and dad will say when they come home from holiday and find out about the party that's gone on while

❝ *When we lack the facts or resources to give us an advantage, we can still explore the world through instinct, intuition and affinity.* **❞**

they were out of the way. Where will they look? What damage will they fail to notice?

There is also a forensic quality to artistic practice. Every day, we are scriptwriters and directors of our lives. Some of this takes place in our heads, as we run a situation forwards in terms of characters and storylines, imagining how it might play out. At other times, we may try to direct a conversation or to arrange our day to provoke the particular kind of encounter we want to see.

We can all do this. We are all capable of being creative. Some take more easily to the arts than others. They find maps in life through literature, celebrate the physicality of life through the visual arts, or express their hope and ambition in music. Some people enjoy the discipline; the hours of practice that give sensitivity to the rhythms and rises and falls of our culture; that open eyes and ears to patterns and give the

student the confidence to take these patterns, play with them and turn them into something original.

Creativity in our lives may take many forms. It need have no immediate outcome. Its purpose can be the happiness of the process, and how it helps us to discover more about ourselves. But the pleasure and playfulness of creativity shouldn't mask the serious power it can have over our lives, especially when coupled with artistic practice: it can transform us as individuals and change our understanding of others.

DEFINING OUR PLACE IN SOCIETY

The arts have historically cut across social and economic divides, uniting the artist and client, the patrons and the hangers-on. As a sector, it offers a working environment

> " *Creativity in our lives may take many forms. It need have no immediate outcome. Its purpose can be the happiness of the process.* "

that values wide experiences, different perspectives and unusual skills, providing the means for talent to circumvent Britain's enduring social barriers. The arts can potentially offer each of us a ladder.

People often become part of the arts world at a transitional stage in their lives: they may train at drama school, at art school or at a music conservatoire, but go on to be lawyers, financiers or engineers. The skills they learn seem at the time to be an end in themselves; but afterwards prove to be in demand in the wider world,

because they teach people how to challenge the status quo.

Artistic practice makes us more adaptable as characters. It provides us with social opportunities, confidence and close emotional bonds. It encourages us to interact, to think about other people and to see our own potential for growth and change.

Many young people practise the arts but find that their involvement drops off as they reach the end of their teens. Life takes over; music and art remain a part of the world they move through, but they leave behind their childhood interests. And yet, when these same people encounter some kind of crisis, they often find themselves going back to the library, deciding to write a book or picking up that old instrument, and they discover that there is a creative continuum that survives the broken elements of their lives.

The arts show what is possible – that the reality around us is not fixed; that the world is malleable. They can make us feel empowered, able to express our voices and aspirations. And that can be so important if, for example, you are growing up in poor housing in a post-industrial town, or if you are a member of one of the many ethnic minority groups that make up the mosaic of our society, but remain under-represented in the corridors of power.

Artistic practice, across the community and within individual lives, can help all of us, no matter our circumstances. Hull's year as UK City of Culture has surprised many

> 66 *The arts show what is possible – that the reality around us is not fixed; that the world is malleable.* 99

people with the way in which it has successfully involved and engaged all of Hull's numerous communities. Even something so simple as helping people to personalise the colours of the lighting outside their flats has had an impact, so important is the sense of individual agency that creative decisions can bring.

CREATIVITY IS A DELIGHT

Creativity is one of the better and healthier narcotics. Artists and creatives of all sorts know the intoxication of being 'in the zone' – a phrase more often associated with sportspeople. It's that moment when you inhabit a state of focused but relaxed activity and the work seems to flow through you. It's a state reached in moments of mastery. A writer will feel that

they have within them enough detail about the world they are imagining for it to come alive and create itself according to its own rules. A choreographer can find themselves inventing effortlessly in the rehearsal room, in the moment.

These moments are hard won. But they are evidence of the eloquence and power of the creative subconscious.

Art is always suggesting connections and relationships, comparing experiences and versions; evoking emotions and trying them in a different and distant context. Art helps us to understand what we feel about our world, as well as what we think; sometimes it asks us to think with our feelings and to feel intelligently, trusting our intuition and our empathy.

Go a step further and explore your own creativity and for a moment you might transcend time and space. The creative

act can recall the past, elevate the present, and imagine the future. We can stand outside time. We can make huge connections across the ages, trace the lines of influence and imagine where we are going. And the wonder is that these experiences can be recorded in a book or on a canvas or as a sculpture, so that the moment is available to others every time a human encounters it.

However you want to describe the power of creativity, it finds its expression first with individuals. As we have seen, it flows out into the community and on into the social and economic well-being of the nation, but it comes to life from the day that each of us is born. That's why I believe the key to harnessing its full potential is to give all of our children an education filled with creativity. That's the case I'll be making in the next – and final – chapter.

4

CREATIVITY AND EDUCATION

In the very first months and years of their lives, babies are on an especially super-charged voyage of creative discovery. Watch a toddler at play and you will see someone delighting in finding things out by trial and error, and inventing new ways of doing things.

Admittedly, their discoveries are almost certainly not going to be new to us adults. They were, in all probability, discoveries that we ourselves made back when we

were their age. But to a young child, they are momentous. They're creatively solving the challenges that face them – exploring uncharted territory; trying things out for the very first time; making giant steps forward.

As that child gets older though, school and then adult life can train out this sense of discovery. The pressure to pass exams and to get a job is enormous. We can easily forget the importance of being creative. And, unless it's nurtured, that natural creativity inside us all can fizzle away and die.

For all the reasons outlined earlier in this book, I believe we need to build a generation of culturally literate young people

> 66 *Unless it's nurtured, that natural creativity inside us all can fizzle away and die.* 99

who are capable of creative thought and action, and who are able to move into adulthood with a genuine understanding of culture and the ability to make informed critical decisions about the cultural and creative activities in which they engage later in their lives. And that means educating our children so that their creativity has every conceivable chance to grow. We mustn't allow it to wither away.

THE POWER OF CULTURAL EDUCATION

The value of cultural education subjects such as art and design, dance, drama and music in the lives of young people is well recognised in education systems the world over. During her husband's time at the White House, the USA's former first lady, Michelle Obama, made it one of her

priorities to improve cultural education for those from poorer socio-economic backgrounds:

> Arts education is not a luxury, it's a necessity. It's really the air many of these kids breathe. It's how we get kids excited about getting up and going to school in the morning. It's how we get them to take ownership of their future.[1]

Before we continue, I'd like to take a moment to nail the great fallacy that these cultural education subjects are an easy option. On the contrary, they require hard work, dedication, the acquisition of knowledge, the development of practical skills and the application of analytical understanding. They are not an alternative to 'more academic' subjects and they are not a soft option for 'less academic' young people.

They are part of a process of education that results in a young person becoming a fully rounded human being.

I should reiterate that creativity is not the sole preserve of these arts-based subjects – it is just as important for scientists, medics and engineers as it is for artists and performers. And just as academic rigour, discipline, knowledge and practice are important for developing the next generation of mathematicians, computer scientists, physicists, engineers and chemists, so the same is true for young artists,

> **"** *Creativity is not the sole preserve of these arts-based subjects – it is just as important for scientists, medics and engineers.* **"**

writers, dancers, actors, musicians, film producers and video-game creators.

But, it's equally important to recognise that subjects such as art and design, dance, drama and music do have an important role to play in a young person's learning and development. These subjects should not be seen merely to have extrinsic value; they have intrinsic value, too – both in terms of the skills they nurture and the academic challenge they represent. They can provide a route into a career in the creative industries; but they are also a valuable part of the overall education of those young people who end up working in completely different sectors, in jobs ranging from accountancy through to zoology.

For those who do follow a pathway into the creative industries, studying cultural education subjects at school and at college or university gives them a taste of the hard

❝ *Subjects such as art and design, dance, drama and music do have an important role to play in a young person's learning and development.* **❞**

graft that will be required during their professional careers. Grayson Perry, member of the Royal Academy and winner of the Turner Prize, is quick to rubbish the idea that success as an artist is some kind of easy ride:

There is a lingering myth that artistic success is God-given and that all the artist need do is lounge around drinking absinthe and then, occasionally, in a fit of impassioned inspiration, knock out a masterpiece in a furious bout of

divinely prompted creation. Rather, in my experience, most successful artists are pragmatic and work-obsessed; in a word, rigorous.[2]

It's a view echoed by the choreographer Twyla Tharp, who emphasises the importance of discipline:

I come down on the side of hard work . . . creativity is a habit, and the best creativity is the result of good work habits. That's it in a nutshell.[3]

And Disney Pixar's Ed Catmull concurs:

Creative people discover and realise their visions over time and through dedicated, protracted struggle. In that way, creativity is more like a marathon than a sprint.[4]

It's not just the creative types who hold this view. It's backed up by scientists, who have conducted research into this area. Psychologist Mihaly Csikszentmihalyi, for example, agrees that creative achievements don't usually come about because of a moment of genius. Instead, they're the result of a hard slog, of the dedicated learning of a craft.[5]

OVERCOMING THE CHALLENGES

So, given that true creativity doesn't just happen by chance, how do we develop an education system that offers the right environment and support for people to learn these skills and put in the hard hours to develop them?

Sir Nicholas Serota's first speech as chair of Arts Council England, shortly after

he took up the role in 2017, was entitled 'A Creative Future in a Changing World'. He argued that creativity should play a significant part in every child's education:

> We should recognise that young people have a right to a broad, high-quality education, which involves a creative as well as an academic training. In a rapidly changing world, in which appearances cannot always be trusted, we will need people who can question, adapt and invent as well as analyse and use existing knowledge.[6]

Nick knows a thing or two about creativity, having been director of the Tate galleries for twenty-nine years, overseeing the development of new Tate sites in Liverpool and St Ives and of Tate Modern in London. And he's not alone in championing the

value of both creativity in education and also of cultural education subjects. In our book *The Virtuous Circle*, Sir John Sorrell, Paul Roberts and I identified what we considered to be the four key types of learning that combine to make a high-quality cultural education.[7]

The first is **knowledge-based**, teaching children about the best of what has been created (for example, great literature, art, architecture, film, music and drama). It introduces young people to a broader range of cultural thought and creativity than they would be likely to encounter in their lives outside school. The second centres on the **development of analytical and critical skills**, which can also be applied across other subjects. The third is **skills-based**, enabling children to participate in and create new culture for themselves (designing a product, drawing, composing music, choreographing

a production, writing and performing poetry or making a short film). And the fourth element centres on the development of an individual's **personal creativity,** which I have talked about throughout the earlier chapters of this book and to which I will return shortly.

Delivering all four of these elements requires us to address two distinct, but not contradictory, challenges.

The first is about ensuring that every child has access to cultural education. To my mind, the primary purpose of education is to create well-rounded human beings who have the capacity to think new thoughts, to solve apparently insurmountable problems, and to contribute to society by enriching the world around them in every conceivable way. As the Cambridge University professor, and Britain's best known classicist, Mary Beard pointed out to her Twitter followers

on the day that A Level results were published in England in 2017, studying is not just about young people getting a well-paid job, it's about them getting an education – and that is a valuable end in itself.

For everybody to be able to make their own creative contribution to society, we must value everybody's creativity, no matter who they are, where they live, or what their background. The rich diversity of our nation is one of our great strengths, but we still need to do more to ensure that everyone from every background has an equal chance of their own creativity being

66 *We must value everybody's creativity, no matter who they are, where they live, or what their background.* 99

widely recognised, developed, understood and valued.

A nation is built around its shared culture: equality of access to that culture strengthens it by ensuring that a huge number of different voices are heard. It gives everyone a chance to succeed, no matter where they start in life.

Everyone should be a cultural insider, understanding what is said, and being familiar with what is meant. But that means that they have to have access to the same points of reference as those people who are already cultural insiders. If a young person doesn't get the chance to read that book, to encounter that music, theatre or dance performance, or to visit that gallery, museum or library, then they're already at a disadvantage to those other, more fortunate young people, who do get to experience these activities as a part of their education,

or because they happen to have been born into families where taking part in cultural activities is regarded as a perfectly normal part of everyday life.

Prince George may currently only be a toddler, but one day he will be our king. In September 2017, he started his formal education at Thomas's Battersea, an independent school in south London. The very first page of the school's website proudly proclaims that the school offers 'a rich and broad curriculum, with Art, Ballet, Drama, ICT, French, Music and PE all taught by specialist teachers from a child's first day in school'.

Prince George's parents, the Duke and Duchess of Cambridge, are to be warmly applauded for actively choosing an education for their son that is rich in creativity. However, for many children and young people from minority communities and

from the least prosperous parts of our society, the arts aren't a part of their lives in the same way. That exclusion holds back their progress. They too should have the opportunities of enjoying art, dance, drama and music, taught by specialist teachers, as part of their school curriculum. To do otherwise would be to allow a huge waste of our national talent, at a time when I would argue we need it more than ever. And if we truly wish to use all our talent, to offer opportunity for all, and to increase social mobility, then access to art and culture must remain high on the agenda for all young people.

> **"** *If we truly wish to use all our talent, then access to art and culture must remain high on the agenda for all young people.* **"**

Reading a book, listening to music, watching a piece of theatre or a dance performance, looking at a work of art, visiting a museum or a library: all of these experiences can be life enhancing. They represent a wonderful voyage of discovery that we can enjoy throughout our lives.

For those of us already on that journey, even if we are the most voracious of arts consumers, there are still so many books unread, so many pieces of music unheard and so many museums and galleries unseen. And the good news is that new works of art are being created every day. Our appetites can never be fully sated in any case. It's a never-ending journey, where we can never quite be certain of the delights waiting around the next corner, not least because many of them have yet to be imagined by the artist who will go on to create them.

For many young people, the journey really gathers pace when they experience a particular piece of art at a particular moment in time that sparks a lifetime of enthusiasm for a genre or for a subject. It can spur them on to find out more by sampling an increasing variety of experiences; some similar, some very different. But, unless they actually have the opportunity to experience that initial moment of connection, whole areas of culture could well remain closed to them forever. We therefore need to enable and encourage young people – and their families – to enjoy age-appropriate, high-quality cultural experiences throughout their childhoods.

However, for their own personal creativity truly to flourish, a young person requires more than just a set of cultural experiences; they need to create their own art too. Being an audience member is only

> **❝** *A young person requires more than just a set of cultural experiences; they need to create their own art too.* **❞**

one half of the creative opportunity from which everyone – and particularly young people – should be able to benefit. Writing a story; composing a song; acting in a play; dancing in an ensemble; directing a film; painting a picture: the physical act of making something new is often an even more magical experience than watching someone else do it in front of your eyes, however good an artist they might be.

We need to remember that for those from the poorest backgrounds, the greatest chance they have of accessing art and culture – and of having their eyes opened

to their own personal creativity – will be in their schools. That's because attendance at school remains the only activity undertaken by virtually all children in this country. It's only by teaching art and design, dance, drama and music as part of every school's classroom-based curriculum – for the smallest child in a nursery class right through to those in their mid-to-late teens – that all young people can be guaranteed access to these subjects, thereby increasing their chances of becoming cultural insiders.

It's a necessity that these subjects are taught as part of the curriculum. If we shift cultural education to the margins, making it an extra-curricular activity, those from the poorest socio-economic backgrounds will be the most likely to miss out. And if subjects such as art and design, dance, drama and music are no longer offered as part of

the core curriculum, schools will no longer have a requirement to employ teachers who are specialists in these subjects, meaning that both classroom lessons and extra-curricular activities will suffer.

I believe that our education system should place far greater importance on the value that expert cultural education teachers bring in sharing knowledge, skills and understanding of their specialism, and often of their own creative practice, too. So, I was thrilled to see recognition for the inspirational work of Andria Zafirakou, an art and textiles teacher at Alperton Community School in the London borough of Brent, when she was named the first UK winner of the Varkey Foundation Global Teacher Prize in 2018. Andria was chosen from more than 30,000 applicants from 170 countries to secure the $1 million award. In her eloquent acceptance

speech she powerfully made the case both for specialist subject teachers and for her own subject, reminding the global audience that:

> Too often we neglect this power of the arts to actually transform lives, particularly in the poorest communities.

Another challenge of delivering an effective cultural education centres around how a young person progresses during their time at school and beyond. If a young person shows an exceptional level of ability in a subject, we have to make sure that there is a suitable training pathway to take them to the highest level of achievement.

In effect, I'm talking about offering a programme of elite training right through school and into further and higher education. Some people will worry about the

word 'elite' and accuse such programmes of being 'elitist', but so long as the pathways to the top are open to all, then I don't think such a charge will stick. Elitism only comes into play when routes to the best training and education are closed off not on grounds of talent but on the basis of who you are and where you come from. We need to work hard to ensure that any programmes we put in place reward all talent regardless of social background.

Whatever a person's background, they have an equal chance of possessing talent. What is unequal is the chance of their potential being fully realised, particularly when they come from the most economically and socially deprived parts of society. Talent is not exclusive. It's inclusive. Talent is everywhere. Opportunity is not.

Chelsea Warr, the director of performance at UK Sport, the National Lottery

funded organisation responsible for the strategy that delivered outstanding Olympic medal success in 2012 and 2016, believes that diversifying talent recruitment methods is key to success in any field:

> Throw your net wide to capture talent, challenge the status quo on your traditional recruitment methods, fish in alternative talent ponds. That enhances your chances of unearthing your future performance genius.[8]

This doesn't just apply in sport; the same is true in the cultural world. So, to maximise the talent we have in this country, we need to make sure that we're identifying and developing all the potential that is out there – not just the talent that self-selects because of advantageous initial opportunities in life.

And it's worth underlining at this point that there is no magic wand that can be waved to make the world change overnight for children from our most disadvantaged communities. It's by no means easy to put in place the conditions needed to help these young people unlock the opportunities that will enable them to fulfil their potential. But that doesn't make it any less worth doing. It just means that we need to recognise that it will take time for the investment to come good.

POWERING THE ECONOMY

Another reason for making creativity central to our education system is that it encourages young people to be original. Certainly, our business leaders want an education system that produces something different.

They want employees who are numerate, literate *and* creative. The American venture capitalist Scott Hartley describes those who specialise in the humanities or social sciences as 'fuzzies', and those who study computer or hard sciences as 'techies'. Contrary to many people's expectations, he argues that it is the former who drive forward the most creative and successful new business ideas.[9]

In 2018, Google's director of engineering Dr Damon Horowitz told a conference that the company thought it as important to hire arts and humanities graduates as those with business and technology degrees.[10] And in his 2011 MacTaggart Lecture in Edinburgh, Eric Schmidt, the executive chairman of Alphabet Inc. (the company that owns Google), was critical of the UK for turning its back on the nurturing of its polymaths.

Tony Wagner, an academic based at Harvard University's Innovation Lab, identifies 'Seven Survival Skills' that young people need in the twenty-first century:

1. Critical thinking and problem solving
2. Collaboration across networks and leading by influence
3. Agility and adaptability
4. Initiative and entrepreneurship
5. Accessing and analysing information
6. Effective oral and written communication
7. Curiosity and imagination[11]

Whole new industries are springing up that fuse together traditional creative skills with new digital technology. Let's take video games as an example. The UK has made a name for itself as a world-leader in this field.

There can be few better examples, if any, of an industry that requires employees with

> **❝** *Whole new industries are springing up that fuse together traditional creative skills with new digital technology.* **❞**

technical and digital knowledge to enable them to write computer code, but also to have the creative skills to develop narratives, design visuals and engage socially with video-game players. They need those seven skills identified by Tony Wagner. But, as Ukie, the trade body for the UK's games and interactive entertainment industry, pointed out in 2017, our education system is failing to fuel the required talent pipeline well enough or quickly enough.[12] And this isn't just about possessing computer coding skills, it's about being all-round creative beings.

CREATING TOMORROW

Of course, one of the big challenges of designing an education system for young people being born today is that we don't know exactly what the world will be like in a quarter of a century's time when they are making their way into the world of work.

It's a fast-changing world out there and we mustn't simply assume that the knowledge, skills and understanding that worked for those of us who were at school in the 1960s, 1970s and 1980s will be as beneficial for a child born in 2020. The world has already changed beyond recognition thanks to the adoption of new technology in every aspect of our day-to-day existence. Think how much an invention such as the iPhone has changed our lives. Yet, the first of these devices only went on sale on 29 June 2007.

Today, it's hard to remember what life was like before their existence.

My message to everyone who cares about the education of our next generation is simple: creativity matters. It goes without saying that literacy and numeracy should be central pillars of every child's education, but so should creativity. By all means equip children with knowledge and skills and understanding across a wide range of subjects, but equip them most of all with the creativity to make best use of their talents and to react to all that the brave new world can throw at them. Nurture their ability to imagine, to innovate, to build and to create. Give them the chance to invent tomorrow.

NOTES

INTRODUCTION

1. *Cultural Transformations: The Impacts of Hull UK City of Culture 2017 – Preliminary Outcomes Evaluation* (Hull: University of Hull Culture, Place and Policy Institute, 2018)

2. Agustín Fuentes, *The Creative Spark: How Imagination Made Humans Exceptional* (New York: Dutton, 2017)

3. Speech by Lemn Sissay at Creative England's Be More Manchester conference, 18 February 2018

4. Ed Catmull, *Creativity, Inc.: Overcoming the Unseen Forces That Stand in the Way of True Inspiration* (London: Bantam, 2014)

5. Adam Grant, *Originals: How Non-conformists Change the World* (London: WH Allen, 2016)

6. Tony Little, *An Intelligent Person's Guide to Education* (London: Bloomsbury, 2016)

1: CREATIVITY AND THE ECONOMY

1. Carl Frey and Michael Osborne, *The Future of Employment: How Susceptible Are Jobs to Computerization?* (Oxford: Oxford Martin School, University of Oxford, 2013)

2. https://www.bankofengland.co.uk/-/media/boe/files/speech/2015/labours-share.pdf?

3. McKinsey Global Institute, *A Future That Works: Automation, Employment, and Productivity* (San Francisco: McKinsey & Company, 2017)

4. *State of the Nation 2017: Social Mobility in Great Britain* (London: Social Mobility Commission, 2017)

5. Charles Handy, *The Second Curve: Thoughts on Reinventing Society* (London: Random House, 2015)

6. *Experimental Culture: A Horizon Scan Commissioned by Arts Council England* (London: Nesta, 2018)

7. https://www.ons.gov.uk/employmentandlabour market/peopleinwork/employmentandemployeetypes/ articles/trendsinselfemploymentintheuk/2018-02-07

8. DCMS Economic Estimates 2016, GVA Report, November 2017

9. Peter Bazalgette, *Independent Review of the Creative Industries* (London: Department for Digital, Culture, Media and Sport, 2017)

10. Adam Grant, *Originals*

2: CREATIVITY IN OUR COMMUNITIES

1. Lauren Fulton and Ben Jupp, *Investing to Tackle Loneliness: A Discussion Paper* (London: Social Finance, 2015)

2. *Fiscal Sustainability Report* (London: Office for Budget Responsibility, 2015)

3. *Future of an Ageing Population* (London: Government Office for Science, 2016)

3: CREATIVITY IN OUR LIVES

1. http://www.mappiness.org.uk

2. Ben Okri, *A Way of Being Free* (London: Head of Zeus, 1997)

4: CREATIVITY AND EDUCATION

1. http://www.presidency.ucsb.edu/ws/index.php?pid=120144

2. Grayson Perry, 'Rigour' in *The Creative Stance* (London: Common-Editions/University of the Arts London, 2016)

3. Twyla Tharp, *The Creative Habit: Learn it and Use it for Life* (New York: Simon & Schuster, 2006)

4. Ed Catmull, *Creativity, Inc.: Overcoming the Unseen Forces That Stand in the Way of True Inspiration* (London: Bantam, 2014)

5. Mihaly Csikszentmihalyi, *Creativity: The Psychology of Discovery and Invention* (New York: HarperCollins, 1996)

6. https://www.artscouncil.org.uk/sites/default/files/download-file/Sir_Nicholas_Serota_No_Boundaries_speech_280317.pdf

7. John Sorrell, Paul Roberts and Darren Henley, *The Virtuous Circle: Why Creativity and Cultural Education Count* (London: Elliott & Thompson, 2014)

8. Owen Slot, *The Talent Lab: The Secrets of Creating and Sustaining Success* (London: Ebury Press, 2017)

9. Scott Hartley, *The Fuzzy and the Techie: Why the Liberal Arts Will Rule the Digital World* (Boston: Houghton Mifflin Harcourt, 2017)

10. https://www.timeshighereducation.com/news/google-leads-search-for-humanities-phd-graduates/416190.article

11. Tony Wagner, *The Global Achievement Gap: Why Even Our Best Schools Don't Teach the New Survival Skills Our Children Need - and What We Can Do About It* (New York: Basic Books, 2009)

12. Ukie, *Powering Up: Manifesto for unlocking growth in the games industry* (2017)

FURTHER READING

In 1968, the renowned physicist David Bohm said that creativity was 'something that is impossible to define in words'. But that didn't prevent him writing and speaking many thousands of words on the subject. And, in the fifty years since, it hasn't stopped a legion of writers and thinkers adding their own definitions of creativity into the mix. Over the centuries, the likes of Plato, Aristotle, Freud and Kant have all weighed in with their views. Here, I have listed those books that I have found to be the most inspiring, incisive and insightful, as well as two that I have had a hand in creating and which are relevant to this subject.

Bazalgette, Peter, *The Empathy Instinct: How to Create a More Civil Society* (London: John Murray, 2017)

Catmull, Ed, *Creativity, Inc.: Overcoming the Unseen Forces That Stand In The Way of True Inspiration* (London: Bantam, 2014)

Csikszentmihalyi, Mihaly, *Creativity: the Psychology of Discovery and Invention* (New York: HarperCollins, 1996)

Fuentes, Agustín, *The Creativity Spark: How Imagination Made Humans Exceptional* (New York: Dutton, 2017)

Grant, Adam, *Originals: How Non-conformists Change the World* (London: WH Allen, 2016)

Handy, Charles, *The Second Curve: Thoughts on Reinventing Society* (London: Random House, 2015)

Harari, Yuval Noah, *Homo Deus: A Brief History of Tomorrow* (London: Harvill Secker, 2016)

Hartley, Scott, *The Fuzzy and the Techie: Why the Liberal Arts Will Rule the Digital World* (Boston: Houghton Mifflin Harcourt, 2017)

Henley, Darren, *The Arts Dividend: Why Investment in Culture Pays* (London: Elliott & Thompson, 2016)

Hegarty, John, *Hegarty on Creativity: There Are No Rules* (London: Thames & Hudson, 2014)

Kaufman, Scott Barry and Gregoire, Carolyn, *Wired to Create: Unravelling the Mysteries of the Creative Mind* (New York: Tarcher Perigree, 2016)

Kurzweil, Ray, *How to Create a Mind: The Secret of Human Thought Revealed* (New York: Viking, 2012)

Lewis, Sarah, *The Rise: Creativity, the Gift of Failure, and the Search for Mastery* (New York: Simon & Schuster, 2014)

Little, Tony, *An Intelligent Person's Guide to Education* (London: Bloomsbury, 2016)

Murphy, Shane, *The Oxford Handbook of Sport and Performance Psychology* (Oxford: Oxford University Press, 2012)

Okri, Ben, *A Way of Being Free* (London: Head of Zeus, 1997)

Piirto, Jane, *Understanding Creativity* (Scottsdale: Great Potential Press, 2004)

Robinson, Ken, *Out of Our Minds: Learning to be Creative* (Chichester: Capstone, 2011)

Sandbrook, Dominic, *The Great British Dream Factory* (London: Allen Lane, 2015)

Sawyer, Keith, *Zig Zag: The Surprising Path to Greater Creativity* (San Francisco: Jossey-Bass, 2013)

Slot, Owen, *The Talent Lab: The Secrets of Creating and Sustaining Success* (London: Ebury, 2017)

Sorrell, John, Roberts, Paul and Henley, Darren, *The Virtuous Circle: Why Creativity and Cultural Education Count* (London: Elliott & Thompson, 2014)

Tharp, Twyla, *The Creative Habit: Learn It and Use It for Life* (New York: Simon & Schuster, 2006)

Thompson, Derek, *Hit Makers: The Science of Popularity in an Age of Distraction* (New York: Penguin, 2017)

Trentmann, Frank, *Empire of Things: How We Became a World of Consumers, from the Fifteenth Century to the Twenty-First* (London: Allen Lane, 2016)

Wagner, Tony, *Creating Innovators: The Making of Young People Who Will Change the World* (New York: Scribner, 2012)

ACKNOWLEDGEMENTS

My colleagues in all nine of our Arts Council England offices across the country are a talented and dedicated bunch, bursting with creativity. And they're a constant source of inspiration to me. They make creative decisions every day as they champion, develop and invest in the very best individual artists, as well as our network of libraries, museums and arts organisations from Cumbria to Cornwall – and everywhere in between.

The mighty Orson Wells once said 'The enemy of art is the absence of limitations', and I am particularly indebted to Will Cohu for helping me both to limit and to expand my thoughts for this book in a coherent way. Thank you also to all those from the Arts Council team who commented on the text including: Abid Hussain, Anne Appelbaum, David Ward, Eleanor Hutchins, Francis Runacres, Hannah Fouracre,

Irene Constantinides, Kate Bellamy, Laura Dyer, Liz Bushell, Mags Patten, Maria Hampton, Michelle Dickson, Nicky Morgan, Owen Hopkin, Paul Bristow, Paul Roberts, Richard Russell, Ross Burnett, Sarah Crown, Simon Mellor, Sue Williamson and Sir Nicholas Serota.

Once again, I must thank everyone at Elliott & Thompson for their careful and patient stewardship of the book, particularly Lorne Forsyth, Jennie Condell, Pippa Crane, Marianne Thorndahl, Alison Menzies and Jonathan Asbury.

Finally, I am very grateful to all of the creative people whom I have been privileged to meet in villages, towns and cities right across England since I joined the Arts Council at the beginning of 2015. England is blessed with hugely talented artists, performers, creators, curators, designers, choreographers, writers, producers, directors, librarians, makers, technologists, technicians, administrators, programmers, researchers, educators, investors and policymakers. They're the ones who have the imagination and the creativity to enable brilliant people and brilliant places to shine ever more brightly. And they deserve all of our thanks for that.

INDEX

INDEX

ABOUT THE AUTHOR

Darren Henley OBE is chief executive of Arts Council England. His two independent government reviews into music and cultural education resulted in England's first National Plan for Music Education, new networks of Music Education Hubs, Cultural Education Partnerships and Heritage Schools, the Museums and Schools programme, the BFI Film Academy and the National Youth Dance Company. Before joining the Arts Council, he led Classic FM for fifteen years. He holds degrees in politics from the University of Hull, in management from the University of South Wales and in history of art from the University of Buckingham. A recipient of the British Academy President's Medal for his contributions to music education, music research and the arts, his books include *The Virtuous Circle: Why Creativity and Cultural Education Count* and *The Arts Dividend: Why Investment in Culture Pays*.